LOUIS COMFORT TIFFANY

at Tiffany & Co.

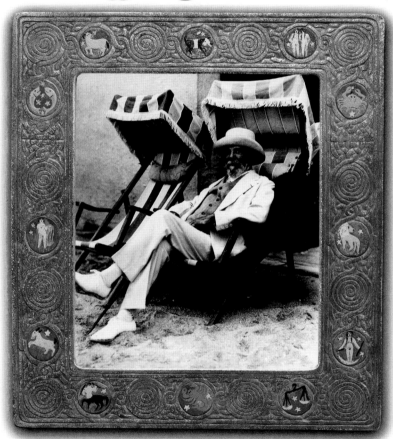

2005 CALENDAR

Andrews McMeel
Publishing

an Andrews McMeel Universal company
Kansas City

ISBN: 0-7407-4630-8
Based on *Louis Comfort Tiffany at Tiffany & Co.*, by John Loring. Copyright © 2002 Tiffany & Co.
Published in 2002 by Harry N. Abrams, Incorporated, New York. (All rights reserved in all countries by Harry N. Abrams, Inc.)

Cover image:
Dragonfly brooch. The body is set with black opals and demantoids, the wings are iridium and platinum, and the wingspan is 2 1/2 inches. *The Jewelers' Circular-Weekly* described the body as "a mass of rich brilliant gems. A large ruby is set in the top of the head, the back is encrusted with green garnets, the eyes are of opals, and the sections of the lower body are of carved opals. This portion, however, seems incidental to the wings, which are of a special metal, spun and drawn to the fineness of a spider thread, and then so delicately woven in the structural lines of the wings that it gives an impression of the natural ones having been taken from the natural body, and joined to a counterfeit resemblance." Tiffany & Co. made several brooches of this design: its 1914 *Blue Book* (catalogue) lists, "Dragon-fly hair ornament set with opals . . . $300." Some were made as late as the 1920s.

2005

JANUARY

S	M	T	W	T	F	S
						1
2	3	4	5	6	7	8
9	10	11	12	13	14	15
16	17	18	19	20	21	22
23	24	25	26	27	28	29
30	31					

FEBRUARY

S	M	T	W	T	F	S
		1	2	3	4	5
6	7	8	9	10	11	12
13	14	15	16	17	18	19
20	21	22	23	24	25	26
27	28					

MARCH

S	M	T	W	T	F	S
		1	2	3	4	5
6	7	8	9	10	11	12
13	14	15	16	17	18	19
20	21	22	23	24	25	26
27	28	29	30	31		

APRIL

S	M	T	W	T	F	S
					1	2
3	4	5	6	7	8	9
10	11	12	13	14	15	16
17	18	19	20	21	22	23
24	25	26	27	28	29	30

MAY

S	M	T	W	T	F	S
1	2	3	4	5	6	7
8	9	10	11	12	13	14
15	16	17	18	19	20	21
22	23	24	25	26	27	28
29	30	31				

JUNE

S	M	T	W	T	F	S
			1	2	3	4
5	6	7	8	9	10	11
12	13	14	15	16	17	18
19	20	21	22	23	24	25
26	27	28	29	30		

JULY

S	M	T	W	T	F	S
					1	2
3	4	5	6	7	8	9
10	11	12	13	14	15	16
17	18	19	20	21	22	23
24	25	26	27	28	29	30
31						

AUGUST

S	M	T	W	T	F	S
	1	2	3	4	5	6
7	8	9	10	11	12	13
14	15	16	17	18	19	20
21	22	23	24	25	26	27
28	29	30	31			

SEPTEMBER

S	M	T	W	T	F	S
				1	2	3
4	5	6	7	8	9	10
11	12	13	14	15	16	17
18	19	20	21	22	23	24
25	26	27	28	29	30	

OCTOBER

S	M	T	W	T	F	S
						1
2	3	4	5	6	7	8
9	10	11	12	13	14	15
16	17	18	19	20	21	22
23	24	25	26	27	28	29
30	31					

NOVEMBER

S	M	T	W	T	F	S
		1	2	3	4	5
6	7	8	9	10	11	12
13	14	15	16	17	18	19
20	21	22	23	24	25	26
27	28	29	30			

DECEMBER

S	M	T	W	T	F	S
				1	2	3
4	5	6	7	8	9	10
11	12	13	14	15	16	17
18	19	20	21	22	23	24
25	26	27	28	29	30	31

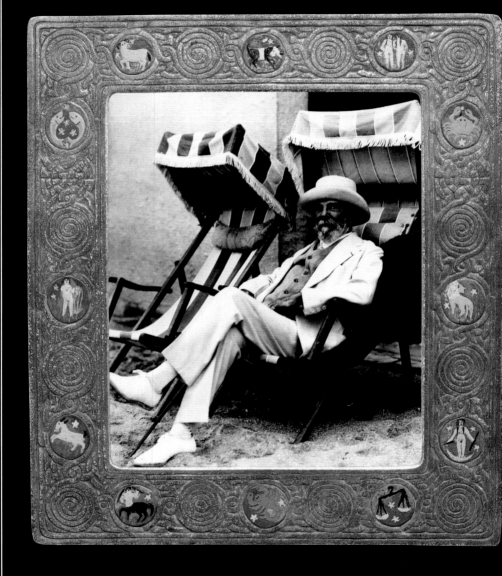

Photograph, taken on Miami Beach, that Louis Comfort Tiffany sent to his family and friends to mark his eightieth birthday, February 18, 1928. The gilt-bronze and enamel frame is from the "Zodiac" desk set, designed about 1903.

• • • • • •

Monday Bartending College: start ✗ **27**

Tuesday **28**

Wednesday **29**

Thursday **30**

Friday **31**

New Year's Day
Kwanzaa ends (USA)

Saturday **1**

Sunday **2**

DECEMBER 2004

S	M	T	W	T	F	S
			1	2	3	4
5	6	7	8	9	10	11
12	13	14	15	16	17	18
19	20	21	22	23	24	25
26	27	28	29	30	31	

JANUARY

S	M	T	W	T	F	S
						1
2	3	4	5	6	7	8
9	10	11	12	13	14	15
16	17	18	19	20	21	22
23	24	25	26	27	28	29
30	31					

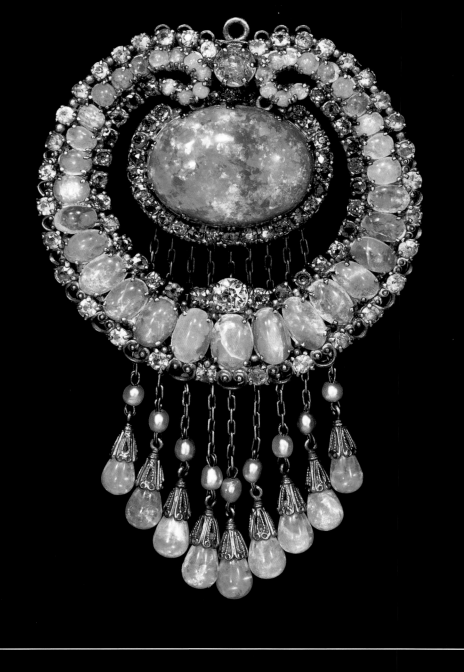

January

Bank Holiday (UK)

Monday ✗ 3

Tuesday 4

Wednesday 5

Thursday 6

Paul's Birthday

Friday Bartending college: end 7

Saturday 8

Sunday 9

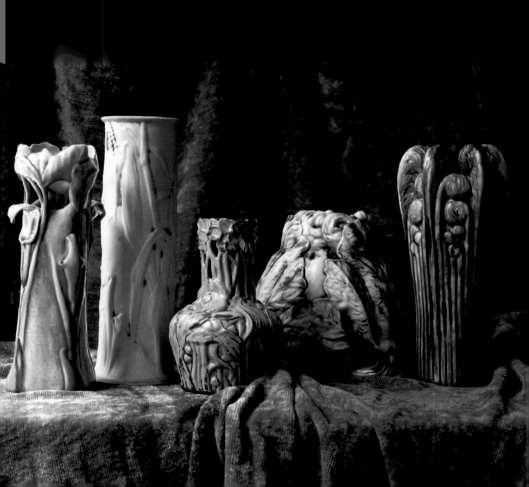

The Favrile pottery vases are from the collection of the art historian Martin Eidelberg, who wrote, "Perhaps the most distinctive and interesting for us today are those vases which are treated sculpturally so that the decoration takes the form of the vase. The walls have a soft fluctuation of form as the plants push out or recede. The rounded, scalloped edges of flowers or unfolding fronds of ferns form the lip of vase."

• • • • • •

January

Monday 10

Tuesday 11

Wednesday 12

Thursday 13

Friday 14

Saturday 15

Sunday 16

JANUARY

S	M	T	W	T	F	S
						1
2	3	4	5	6	7	8
9	10	11	12	13	14	15
16	17	18	19	20	21	22
23	24	25	26	27	28	29
30	31					

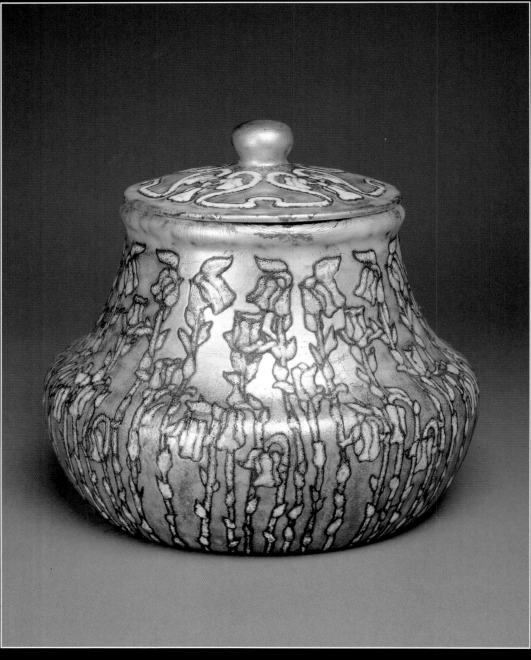

Side view of an enamel-on-copper covered jar decorated with wildflowers called Indian pipes. It was one of Louis Comfort Tiffany's earliest works in enamel and a masterpiece of Art Nouveau design. The jar's decoration is highly unusual for Louis Comfort Tiffany: the symmetrically organized quatrefoil floral pattern on the lid shows the direct influence of Belgium's leading Art Nouveau artist, Henry van de Velde.

• • • • • •

January

Martin Luther King Jr.'s Birthday (observed) (USA)

Monday 17

Tuesday 18

Wednesday 19

Thursday 20

Friday 21

Saturday 22

Sunday 23

JANUARY						
S	M	T	W	T	F	S
						1
2	3	4	5	6	7	8
9	10	11	12	13	14	15
16	17	18	19	20	21	22
23	24	25	26	27	28	29
30	31					

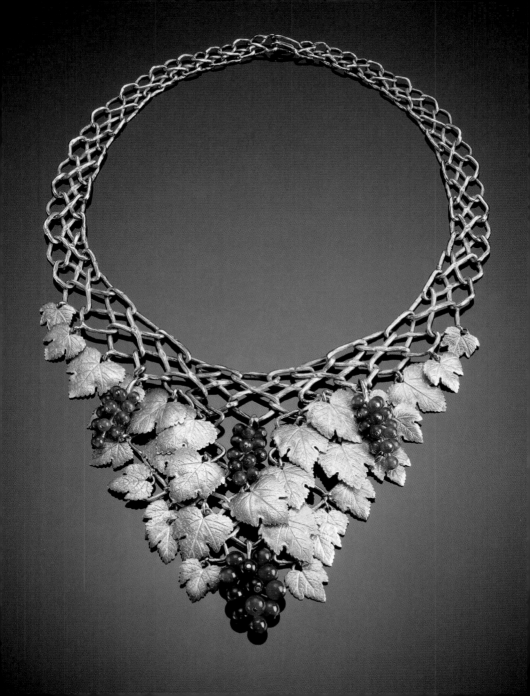

Elaborate necklace
with large gold grape
leaves and nephrite
grape bunches sus-
pended from an
interlocking striated
gold chain represent-
ing a grapevine. The
chain's structure is
similar to that of the
bittersweet necklace
shown at the 1904 St.
Louis Exposition.
Circa 1907. *Toledo
Museum of Art, Ohio*

• • • • •

January

Monday 24

Tuesday 25

Australia Day
Wednesday 26

Thursday 27

Friday 28

Saturday 29

Sunday 30

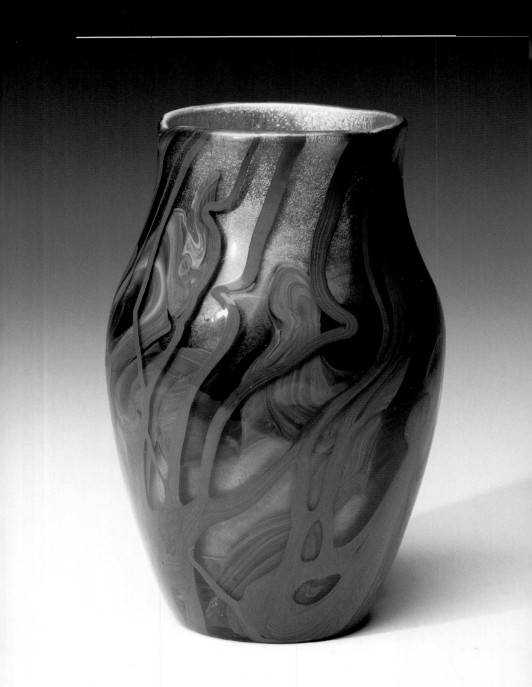

Vase with swirling abstract red and magenta vines on a green background. The strong colors of this "reactive" glass vase suggest that it may have been an early version of the extraordinary "Morning Glory" vases produced in 1912–13.

• • • • • •

Monday **31**

Tuesday **1**

Wednesday **2**

Thursday **3**

Friday **4**

Saturday **5**

Waitangi Day (NZ)

Sunday **6**

JANUARY

S	M	T	W	T	F	S
						1
2	3	4	5	6	7	8
9	10	11	12	13	14	15
16	17	18	19	20	21	22
23	24	25	26	27	28	29
30	31					

FEBRUARY

S	M	T	W	T	F	S
		1	2	3	4	5
6	7	8	9	10	11	12
13	14	15	16	17	18	19
20	21	22	23	24	25	26
27	28					

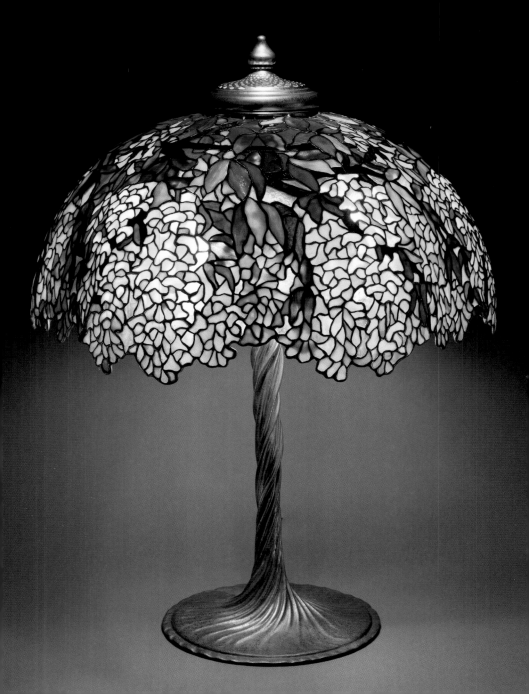

The "Laburnum" leaded-glass lampshade, another popular design, was made in diameters of 22, 24, and 28 inches. The United States government reportedly gave this 22-inch example to Alice Favre of the International Red Cross in Geneva in 1915 to acknowledge her rescue efforts during World War I.

• • • • • •

February

Monday Arone's Birthday 7

Tuesday 8

Ash Wednesday
Wednesday 9

Thursday 10

Friday 11

Saturday 12

Sunday 13

FEBRUARY
S M T W T F S
 1 2 3 4 5
6 7 8 9 10 11 12
13 14 15 16 17 18 19
20 21 22 23 24 25 26
27 28

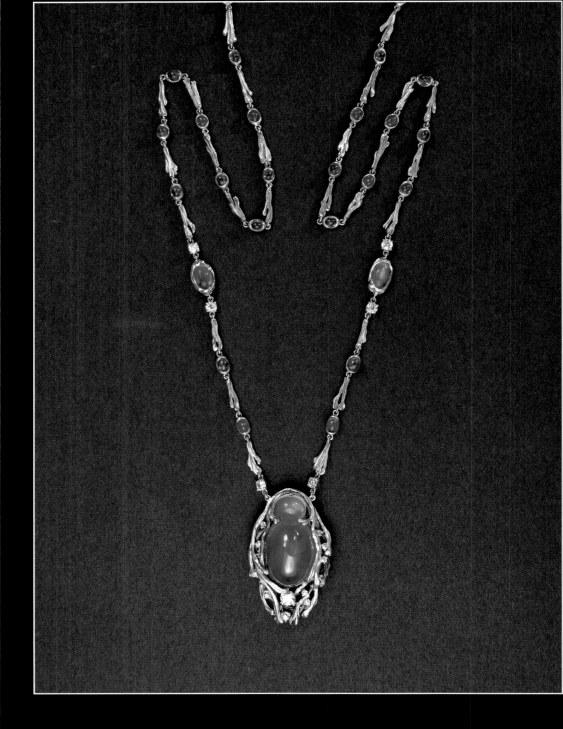

The pendant of this necklace has a star sapphire topped by a moonstone in a seaweed-motif setting interspersed with diamonds. Louis Comfort Tiffany's use of seaweed motifs may have been influenced by seaweed-motif silverware that Charles Osborne and others designed for Tiffany & Co. in the 1880s. This necklace, inspired by earlier Louis Comfort Tiffany seaweed jewels, was probably made circa 1925–30.

• • • • • •

February

St. Valentine's Day

Monday 14

Tuesday 15

Wednesday 16

Thursday 17

Friday 18

Saturday 19

Sunday 20

FEBRUARY						
S	M	T	W	T	F	S
		1	2	3	4	5
6	7	8	9	10	11	12
13	14	15	16	17	18	19
20	21	22	23	24	25	26
27	28					

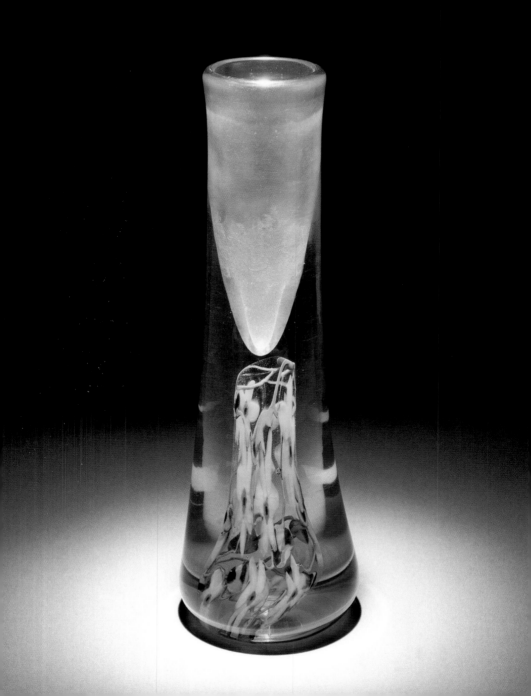

Twelve-inch-tall "Aquamarine" glass vase with daffodils, marked "5797G" and made in 1912. In 1966 James A. Stewart told Robert Koch how "Aquamarine" glass was made. "When you would look at it, its color was inside; its outside was a flint color transparent, you could look right through it The way they decorate that would be six or eight or ten dots of green glass on the first gather We would round that up with the heat in the glory hole, and we'd flatten them out and then we'd take a leaf with that little green dot. We'd run stems all over it. You'd put the hot threads of glass on the pontil and the hot vase in the furnace at 3,300° Fahrenheit, and as soon as you put it in there, the heat would blow the stems all over it, and it would just stick out like a vine and the little green leaves. Now, when the vase was finished, the last thing we'd do, we'd...gather a little iridescent glass ...and that would be the lining when the vase was finished.

• • • • • •

FEBRUARY						
S	M	T	W	T	F	S
		1	2	3	4	5
6	7	8	9	10	11	12
13	14	15	16	17	18	19
20	21	22	23	24	25	26
27	28					

February

Presidents' Day (USA)

Monday 21

Tuesday 22

Wednesday 23

Thursday 24

Friday 25

Saturday 26

Sunday 27

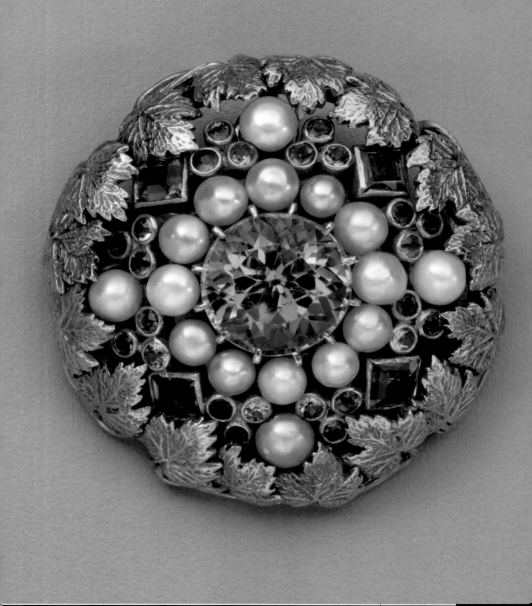

Brooch with a grape-leaf border; the central pink topaz is surrounded by pearls, four square-cut amethysts, and pink and purple sapphire grapes. Circa 1909–10.

· · · · · ·

Monday 28

St. David's Day (UK)

Tuesday 1

Wednesday 2

Thursday 3

Friday 4

Saturday 5

Mothering Sunday (UK)

Sunday 6

FEBRUARY

S	M	T	W	T	F	S
		1	2	3	4	5
6	7	8	9	10	11	12
13	14	15	16	17	18	19
20	21	22	23	24	25	26
27	28					

MARCH

S	M	T	W	T	F	S
		1	2	3	4	5
6	7	8	9	10	11	12
13	14	15	16	17	18	19
20	21	22	23	24	25	26
27	28	29	30	31		

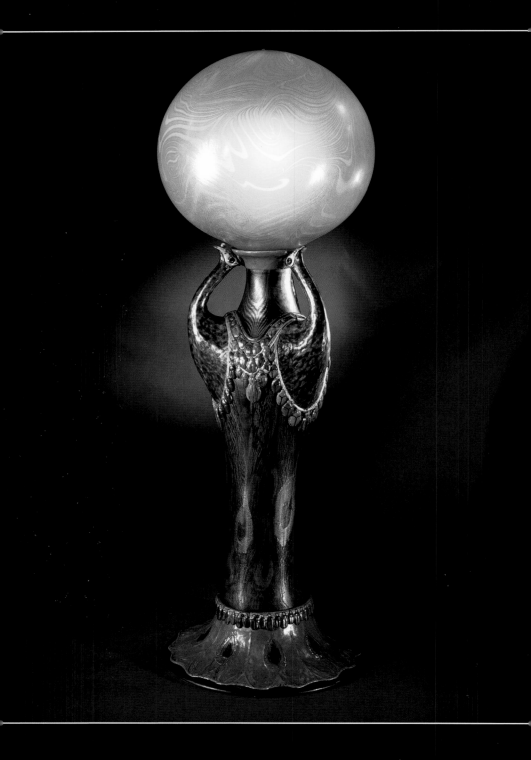

March

Labour Day (Australia—WA)
Eight Hours Day (Australia—TAS)

Monday 7

International Women's Day

Tuesday 8

Wednesday 9

Thursday 10

at Rose Garden
Duran Duran Concert

Friday 11

Saturday 12

Sunday 13

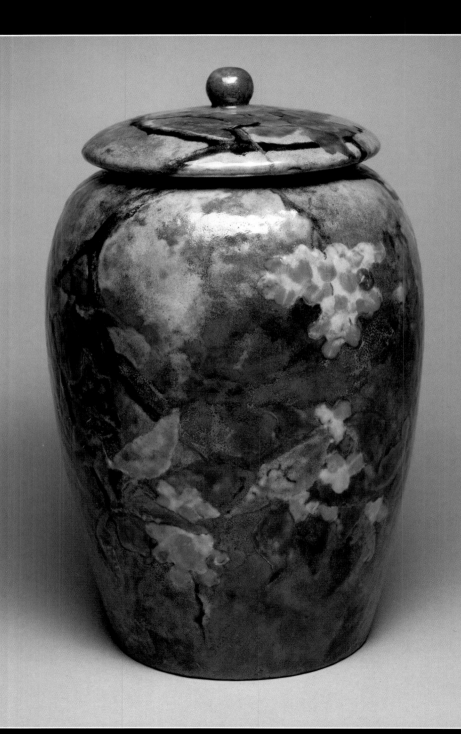

Enamel-on-copper covered jar decorated with flowering shrubs, 9 3/4 inches tall, and probably made about 1900. *Walters Art Gallery, Baltimore, Maryland*

• • • • • •

Labour Day (Australia—VIC)
Canberra Day (Australia—ACT)
Commonwealth Day (Australia, Canada, NZ, UK)

Monday **14**

Tuesday **15**

Wednesday **16**

St. Patrick's Day
Thursday **17**

Friday **18**

Saturday **19**

Palm Sunday
Sunday **20**

MARCH						
S	M	T	W	T	F	S
		1	2	3	4	5
6	7	8	9	10	11	12
13	14	15	16	17	18	19
20	21	22	23	24	25	26
27	28	29	30	31		

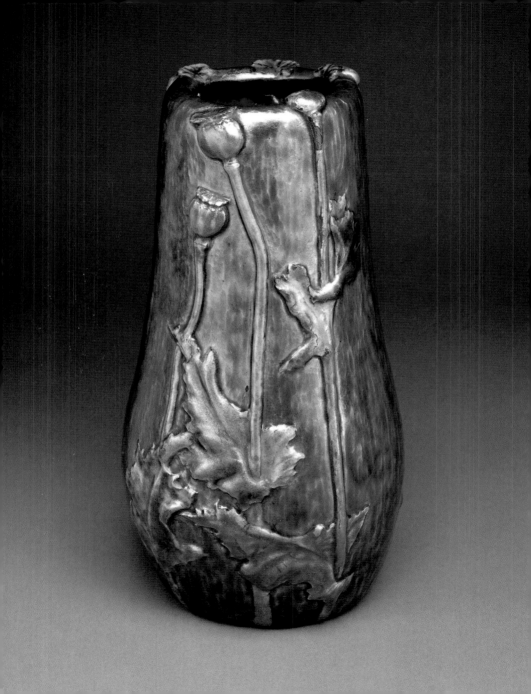

Repoussé-chased
enamel-on-copper
vase with iridescent
green and mauve
poppies on an
iridescent purple
ground, 10 7/8
inches tall. Stamped
"SG256," it was
probably made
about 1905.

• • • • • •

March

Monday 21

Tuesday 22

Wednesday 23

Thursday 24

Purim
Good Friday (Western)
Friday 25

Easter Saturday (Australia—except VIC, WA)
Saturday 26

Easter (Western)
Sunday 27

MARCH

S	M	T	W	T	F	S
		1	2	3	4	5
6	7	8	9	10	11	12
13	14	15	16	17	18	19
20	21	22	23	24	25	26
27	28	29	30	31		

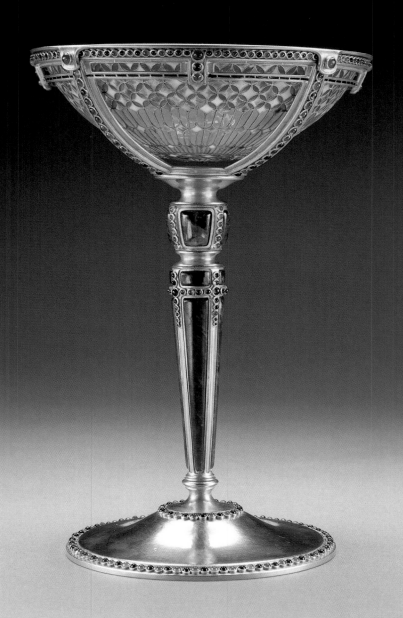

Gold cup, 8 inches tall and 5 1/4 inches in diameter. The bowl has a geometric pattern in translucent plique-à-jour blue, pale green, yellow, and mauve enamel; it is suspended from four supports, which, like the stem and foot, are set with amethysts and green jade.

• • • • • •

Easter Monday (Australia, Canada, NZ, UK—except Scotland)

Monday 28

Tuesday 29

Wednesday 30

Thursday 31

Friday 1

Saturday 2

Sunday 3

MARCH

S	M	T	W	T	F	S
		1	2	3	4	5
6	7	8	9	10	11	12
13	14	15	16	17	18	19
20	21	22	23	24	25	26
27	28	29	30	31		

APRIL

S	M	T	W	T	F	S
					1	2
3	4	5	6	7	8	9
10	11	12	13	14	15	16
17	18	19	20	21	22	23
24	25	26	27	28	29	30

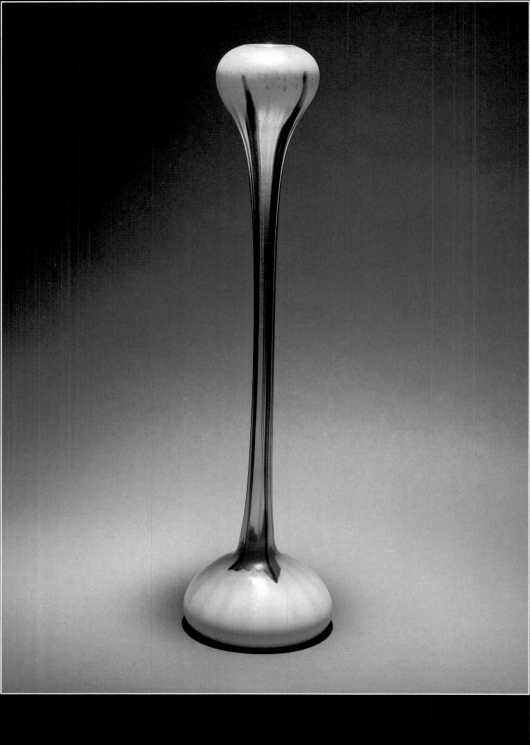

April

Extraordinary 22-
inch-tall vase in the
form of an elongated
crocus growing from
its bulb. The vase is
unmarked, but it is
unquestionably
Tiffany Favrile glass.

• • • • • •

Monday 4

Tuesday 5

Wednesday 6

Thursday 7

Friday 8

Saturday 9

Sunday 10

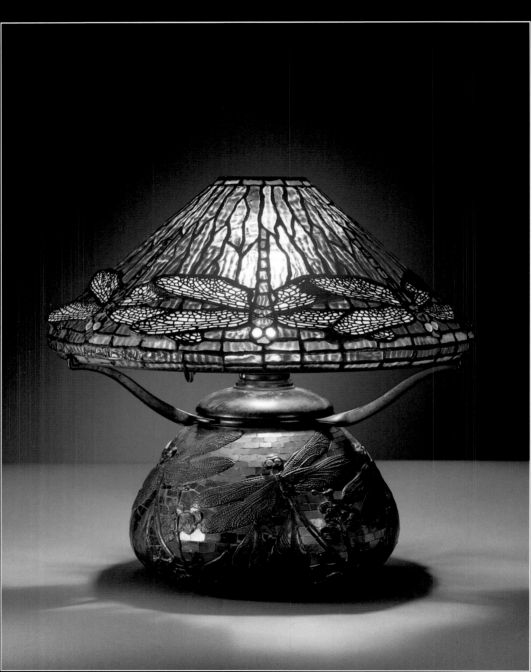

The "Dragonfly" lampshade, Tiffany's most popular leaded-glass shade, was produced in many colors and several shapes for more than twenty years. The original shade, designed by Mrs. Clara Driscoll, was one of the first two documented Tiffany leaded-glass lamp-shades. The Favrile glass mosaic and bronze dragonfly base on the lamp shown here (origi-nally a kerosene lamp) is the model shown at the Paris Exposition.

• • • • • •

April

| Monday | 11 |

| Tuesday | 12 |

| Wednesday | 13 |

Bank Holiday (Australia—TAS)
| Thursday | 14 |

| Friday | 15 |

| Saturday | 16 |

| Sunday | 17 |

APRIL

S	M	T	W	T	F	S
					1	2
3	4	5	6	7	8	9
10	11	12	13	14	15	16
17	18	19	20	21	22	23
24	25	26	27	28	29	30

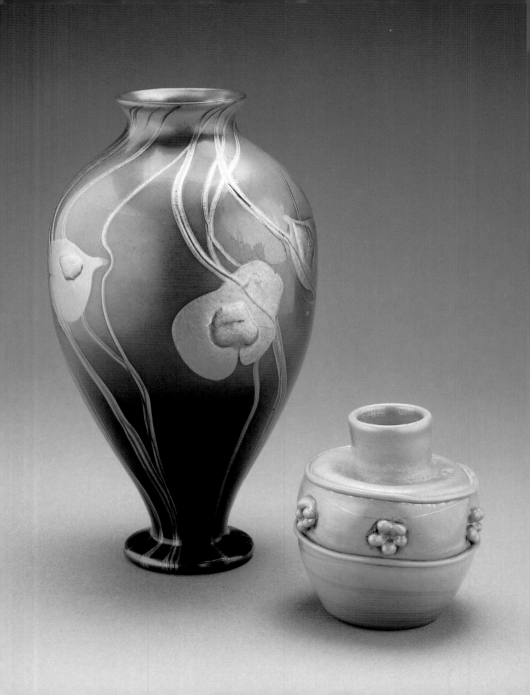

Monday 18

Tuesday 19

Wednesday 20

Thursday 21

Earth Day
Friday 22

St. George's Day (UK)
Saturday 23

First Day of Passover
Sunday 24

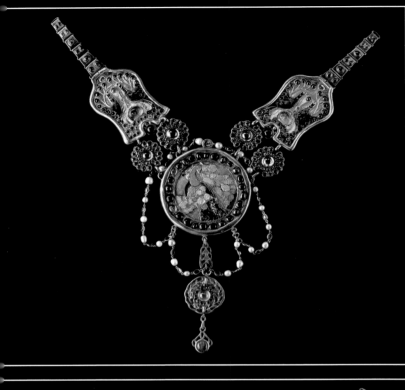
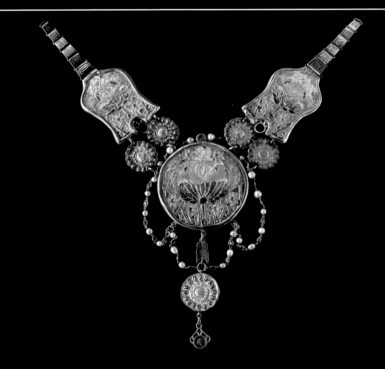

Front and back of the "Peacock" necklace that Louis Comfort Tiffany intended for the 1904 St. Louis Exposition. The central medallion depicting a peacock "is a mosaic of opals, amethysts and sapphires. The less large pieces that adjoin the center are of enamel on gold repoussé work, lighted up with opals and rubies, emeralds being used to relieve the colors. The back of the big centerpiece has a decoration of flamingoes and the lowest point of the pendant below is a single large ruby, selected not for its costliness but for the exact shade of red."

• • • • • •

Anzac Day (Australia, NZ)

Monday 25

Tuesday 26

Wednesday 27

Thursday 28

Holy Friday (Orthodox)

Friday 29

Saturday 30

Last Day of Passover
Easter (Orthodox)

Sunday 1

APRIL						
S	M	T	W	T	F	S
					1	2
3	4	5	6	7	8	9
10	11	12	13	14	15	16
17	18	19	20	21	22	23
24	25	26	27	28	29	30

MAY						
S	M	T	W	T	F	S
1	2	3	4	5	6	7
8	9	10	11	12	13	14
15	16	17	18	19	20	21
22	23	24	25	26	27	28
29	30	31				

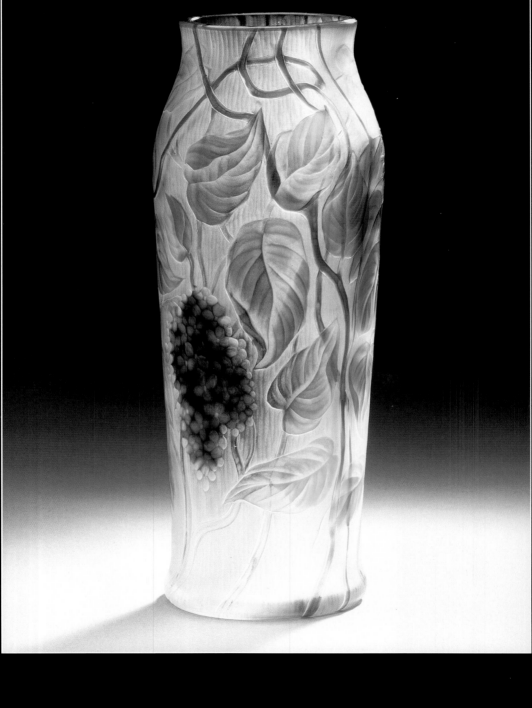

May

Intaglio-carved vase decorated with lilacs, 11 3/4 inches tall. Marked "844A," it was made in 1906. The carving was undoubtedly the work of Ernest Flogel, who was born in Austria in 1867 and emigrated to America in 1879. The vase sold for $23,500 at Christie's on December 8, 2000.

• • • • • •

Labour Day (Australia—QLD)
Early May Bank Holiday (Eire, UK)

Monday 2

Tuesday 3

Wednesday 4

Thursday 5

Friday 6

Saturday 7

Mother's Day (USA, Australia, Canada, NZ)

Sunday 8

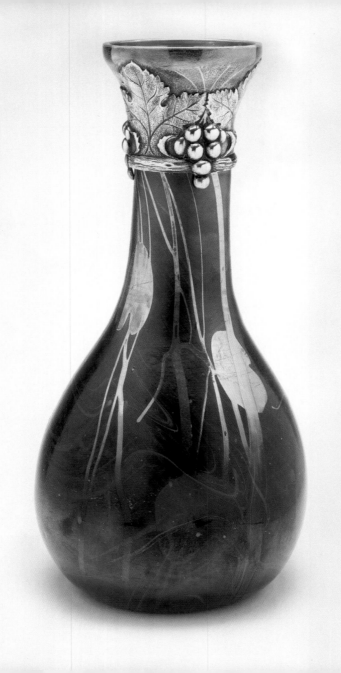

May

Monday 9

Tuesday 10

Wednesday 11

Thursday 12

Friday 13

Saturday 14

Sunday 15

MAY							
S	M	T	W	T	F	S	
	1	2	3	4	5	6	7
8	9	10	11	12	13	14	
15	16	17	18	19	20	21	
22	23	24	25	26	27	28	
29	30	31					

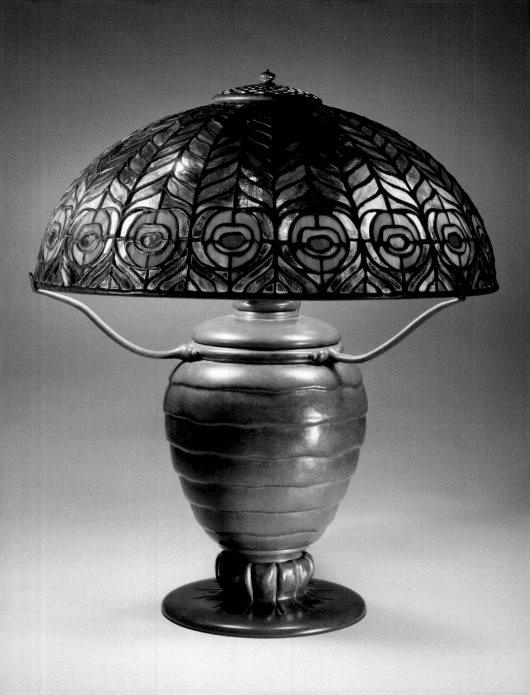

"Crimson Peacock"
leaded-glass lamp-
shade, 16 inches in
diameter, on a
bronze "Bee Hive"
base.

Monday 16

Tuesday 17

Wednesday 18

Thursday 19

Friday 20

Armed Forces Day (USA)

Saturday 21

MAY
S	M	T	W	T	F	S
1	2	3	4	5	6	7
8	9	10	11	12	13	14
15	16	17	18	19	20	21
22	23	24	25	26	27	28
29	30	31				

Sunday 22

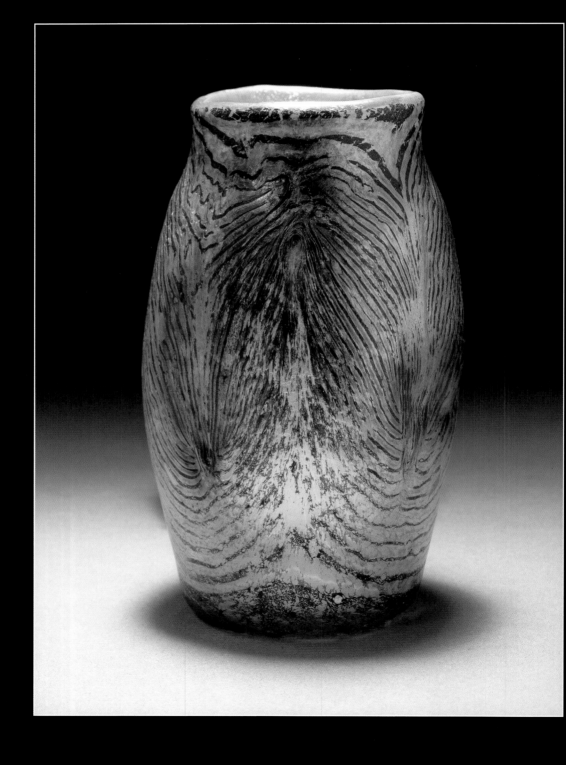

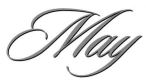

May

Exceptionally fine "Antique" glass vase with feather patterns. Marked "1521K," it was made in 1916. Like "Cypricote" glass, "Antique" glass replicates the effect of corrosion over time; in this example the effect was achieved with iridescent glass threads.

• • • • • •

Victoria Day (Canada)

Monday 23

Tuesday 24

Wednesday 25

Thursday 26

Friday 27

Saturday 28

Sunday 29

MAY

S	M	T	W	T	F	S
1	2	3	4	5	6	7
8	9	10	11	12	13	14
15	16	17	18	19	20	21
22	23	24	25	26	27	28
29	30	31				

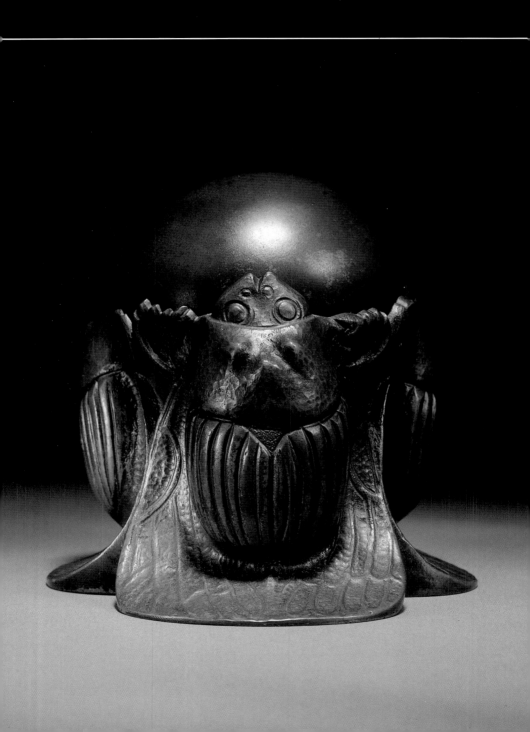

May/June

This model was one of seventeen ink-stands in a 1902 Tiffany Studios photograph, and was number 857 in the 1906 Tiffany Studios price list, where it was described, "INK-STAND, Metal, 3 Scarabs . . . 25.00."

• • • • • •

Memorial Day (USA)
Spring Bank Holiday (UK)

Monday — 30

Tuesday — 31

Wednesday — 1

Thursday — 2

Friday — 3

Saturday — 4

Sunday — 5

MAY						
S	M	T	W	T	F	S
1	2	3	4	5	6	7
8	9	10	11	12	13	14
15	16	17	18	19	20	21
22	23	24	25	26	27	28
29	30	31				

JUNE						
S	M	T	W	T	F	S
			1	2	3	4
5	6	7	8	9	10	11
12	13	14	15	16	17	18
19	20	21	22	23	24	25
26	27	28	29	30		

Favrile glass
"Paperweight"
vase decorated with
jonquils. Marked
"135 A-coll.," it was
made circa 1900 for
Louis Comfort
Tiffany's personal
collection and later
passed to the
Metropolitan
Museum of Art.
*Metropolitan
Museum of Art,
New York*

• • • • • •

June

Monday 6

Tuesday 7

Wednesday 8

Thursday 9

Friday 10

Saturday 11

Sunday 12

JUNE						
S	M	T	W	T	F	S
			1	2	3	4
5	6	7	8	9	10	11
12	13	14	15	16	17	18
19	20	21	22	23	24	25
26	27	28	29	30		

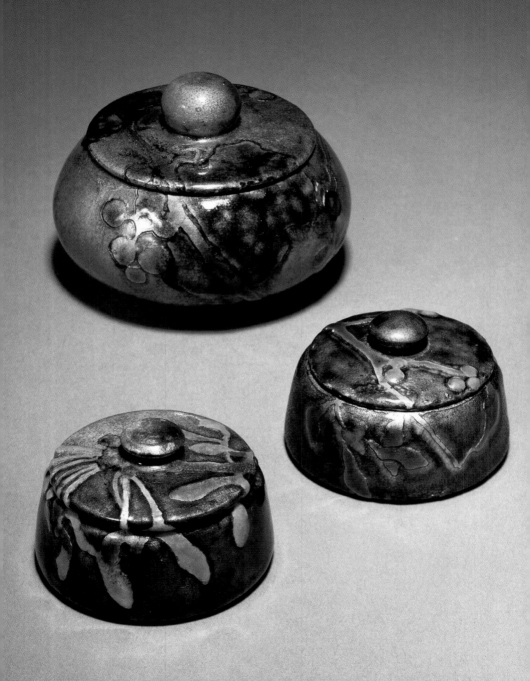

Three small enamel boxes. The berries and seeds of Native American vines and trees, such as bitter-sweet and maple, were popular motifs in LCT's designs.

• • • • • •

June

Queen's Birthday (Australia—except WA)

Monday 13

Flag Day (USA)

Tuesday 14

Wednesday 15

Thursday 16

Friday 17

Saturday 18

Father's Day (USA, Canada, UK)

Sunday 19

JUNE						
S	M	T	W	T	F	S
			1	2	3	4
5	6	7	8	9	10	11
12	13	14	15	16	17	18
19	20	21	22	23	24	25
26	27	28	29	30		

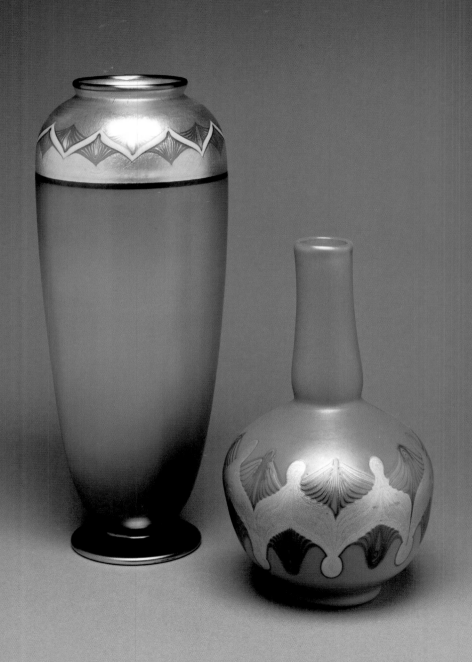

June

Monday 20

Tuesday 21

Wednesday 22

Thursday 23

Friday 24

Saturday 25

Sunday 26

The 18-karat-gold, 6-inch-square "Four Seasons" jewel box that Tiffany & Co. showed at the 1915 San Francisco Exposition. The box's cloisonné panels represent the seasons: a flowering cherry branch and tulips represent spring; a chestnut branch and poppies, summer; grapes and peaches, autumn; snow-covered pine branches and fire, winter. White opals, tourmalines, blue and pink sapphires, and chrysoprases surround the enamel panels.
Charles Hosmer Morse Museum of American Art, Winter Park, Florida

• • • • • •

June/July

Monday 27

Tuesday 28

Wednesday 29

Thursday 30

Canada Day
Friday 1

Saturday 2

Sunday 3

JUNE						
S	M	T	W	T	F	S
			1	2	3	4
5	6	7	8	9	10	11
12	13	14	15	16	17	18
19	20	21	22	23	24	25
26	27	28	29	30		

JULY						
S	M	T	W	T	F	S
					1	2
3	4	5	6	7	8	9
10	11	12	13	14	15	16
17	18	19	20	21	22	23
24	25	26	27	28	29	30
31						

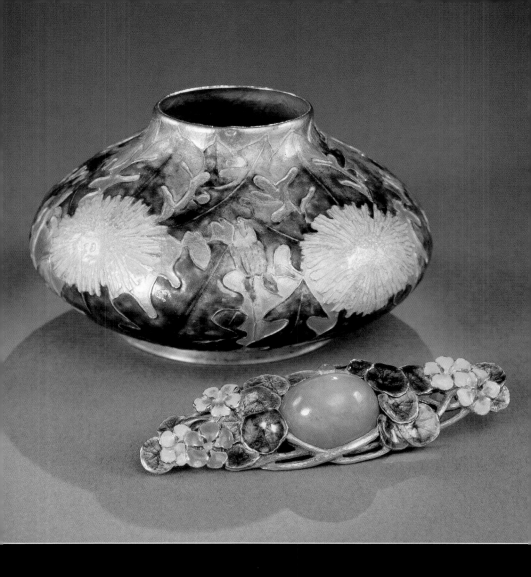

At top, small gold vase—2 7/8 inches in diameter—with champlevé enamel dandelion blossoms and leaves. Its archival photograph is labeled "J421," indicating that it was made in 1907. The high quality of its workmanship indicates that it was made by Tiffany & Co.'s jewelers. At bottom, bar brooch with an oval cabochon serpentine from New Jersey and enamel-on-gold marsh marigolds. The serpentine was provided by Tiffany's gemologist, George Frederick Kunz, who was fond of this local semi-precious stone.

• • • • • •

July

Independence Day (USA)

Monday **4**

Tuesday **5**

Wednesday **6**

Thursday **7**

Friday **8**

Saturday **9**

Sunday **10**

JULY						
S	M	T	W	T	F	S
					1	2
3	4	5	6	7	8	9
10	11	12	13	14	15	16
17	18	19	20	21	22	23
24	25	26	27	28	29	30
31						

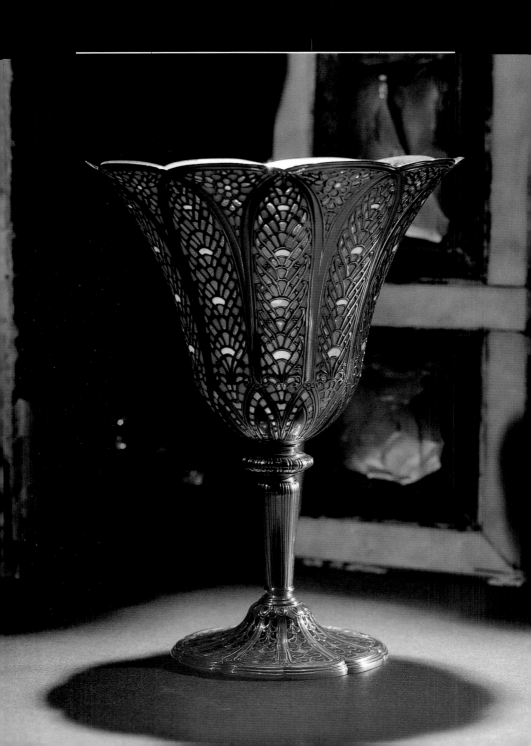

Twenty-karat-gold
and plique-à-jour
enamel cup made in
1924. Its blue, green,
red, and yellow
panels recall Gothic
lancet windows, but
the stylized peacock
feathers and flowers
were inspired by
Islamic art. The cup
was made for Louis
Comfort Tiffany
himself and has
descended in his
family.

.

July

Monday 11

Battle of the Boyne Day (Northern Ireland)
Tuesday 12

Wednesday 13

Thursday 14

Friday 15

Saturday 16

Sunday 17

JULY

S	M	T	W	T	F	S
					1	2
3	4	5	6	7	8	9
10	11	12	13	14	15	16
17	18	19	20	21	22	23
24	25	26	27	28	29	30
31						

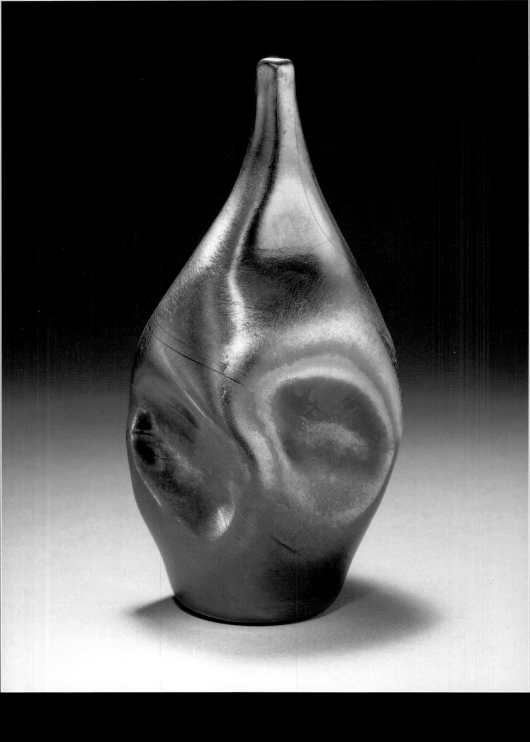

Unusually shaped
iridescent Favrile
glass vase. Marked
"W9436," it was
made in 1905.

• • • • • •

Monday **18**

Tuesday **19**

Wednesday **20**

Thursday **21**

Friday **22**

Saturday **23**

Sunday **24**

JULY						
S	M	T	W	T	F	S
					1	2
3	4	5	6	7	8	9
10	11	12	13	14	15	16
17	18	19	20	21	22	23
24	25	26	27	28	29	30
31						

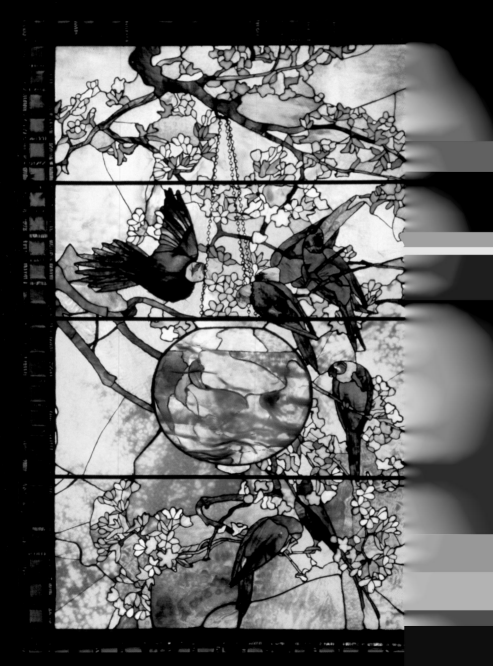

Stained-glass window, 77 by 38 1/2 inches, made for the 1893 World's Columbian Exposition in Chicago; Louis Comfort Tiffany placed it in his "Light Room" at the fair. His catalogue described it as portraying "a number of paroquets [parakeets] resting upon a branch of a fruit-tree in blossom, from which is hanging a globe of gold fishes; the effect produced is most realistic, and has been obtained without the use of paint or enamels, solely by using opalescent glass in accordance with the principles that govern mosaic work." Some of the parakeets were based on plates in John James Audubon's *The Birds of America*.

• • • • • •

Monday 25

Tuesday 26

Wednesday 27

Thursday 28

Friday 29

Saturday 30

Sunday 31

JULY						
S	M	T	W	T	F	S
					1	2
3	4	5	6	7	8	9
10	11	12	13	14	15	16
17	18	19	20	21	22	23
24	25	26	27	28	29	30
31						

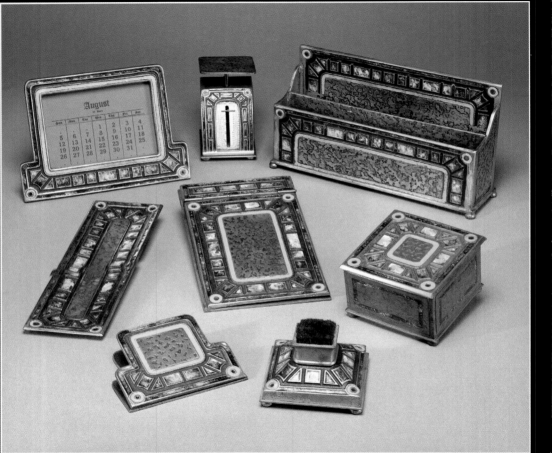

Bronze desk set ornamented with enamel squares and circles, made in the 1920s. *Top row:* perpetual calendar, letter scale, and paper rack. *Center row:* pen tray, notepad, and box. *Bottom row:* paper clip and pen wiper.

• • • • • •

August

Monday　　　　　　　　　1

Tuesday　　　　　　　　　2

Wednesday　　　　　　　　3

Thursday　　　　　　　　　4

Friday　　　　　　　　　　5

Saturday　　　　　　　　　6

Sunday　　　　　　　　　　7

AUGUST

S	M	T	W	T	F	S
	1	2	3	4	5	6
7	8	9	10	11	12	13
14	15	16	17	18	19	20
21	22	23	24	25	26	27
28	29	30	31			

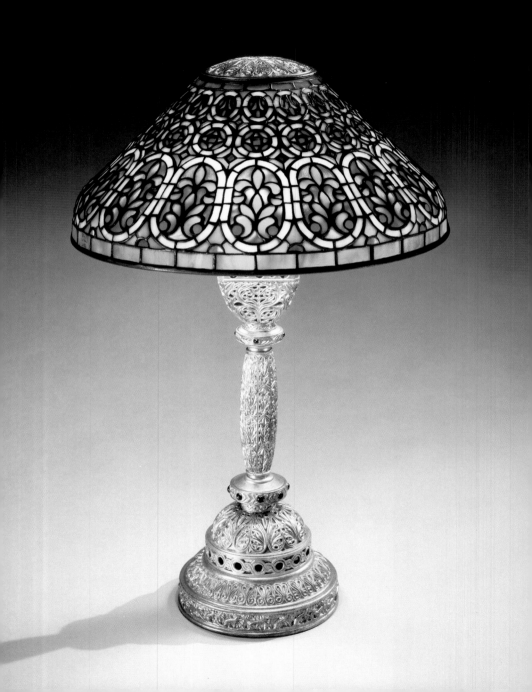

August

Monday 8

Tuesday 9

Wednesday 10

Thursday 11

Friday 12

Saturday 13

AUGUST						
S	M	T	W	T	F	S
	1	2	3	4	5	6
7	8	9	10	11	12	13
14	15	16	17	18	19	20
21	22	23	24	25	26	27
28	29	30	31			

Sunday 14

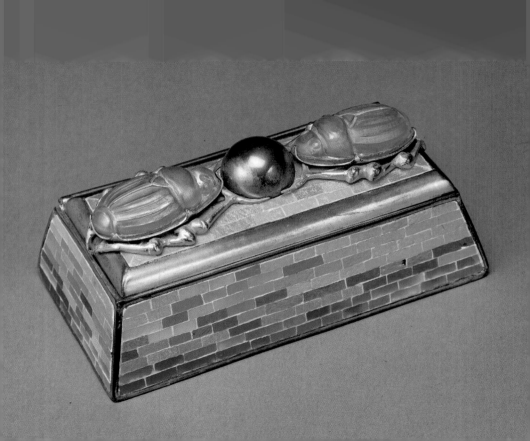

Favrile glass mosaic box with an elongated, truncated pyramid shape. The gilt-edged lid has two Favrile glass scarabs with gilt legs clasping a gilt hemisphere: this is a three-dimensional representation of the ancient Egyptian beetle-and-ball hieroglyph denoting the sun that appears in different forms on other Louis Comfort Tiffany objects.

• • • • • •

August

Monday 15

Tuesday 16

Wednesday 17

Thursday 18

Friday 19

Saturday 20

Sunday 21

AUGUST						
S	M	T	W	T	F	S
	1	2	3	4	5	6
7	8	9	10	11	12	13
14	15	16	17	18	19	20
21	22	23	24	25	26	27
28	29	30	31			

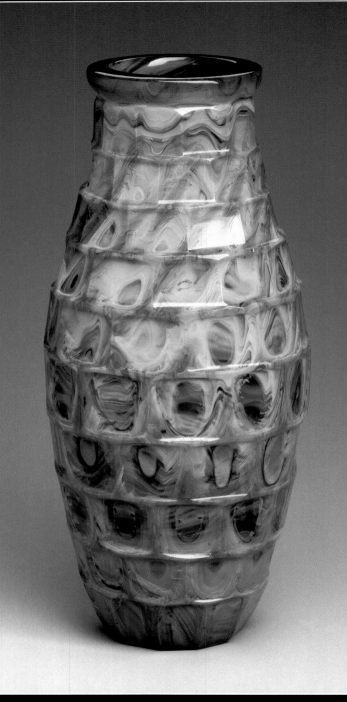

"Agate" glass vase, 10 1/2 inches tall; it is marked "C524," dating it to 1895. It has rows of incised "windows" revealing swirls in the glass; other "Agate" glass pieces have facets like gemstones. The Corona factory made agate glass by mixing several colors of opaque glasses in a low-temperature pot, then stirring the pot to create striations. The surfaces of the cooled pieces were panel-cut and polished to reveal swirling, agatelike patterns beneath.

• • • • • •

Monday 22

Tuesday 23

Wednesday 24

Thursday 25

Friday 26

Saturday 27

Sunday 28

AUGUST

S	M	T	W	T	F	S
	1	2	3	4	5	6
7	8	9	10	11	12	13
14	15	16	17	18	19	20
21	22	23	24	25	26	27
28	29	30	31			

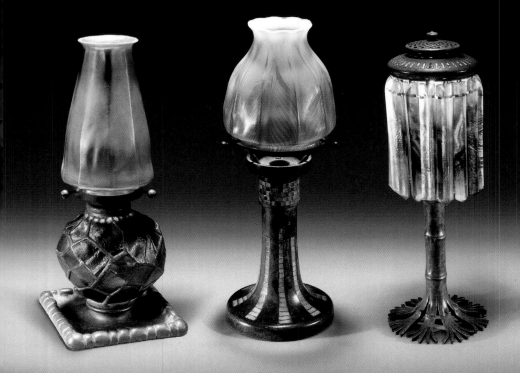

Three desk or mantelpiece lamps. *Left:* Tiffany Studios described this lamp model in its 1906 price list, "1 light, turtleback body, square base"; the price was $30. *Center:* described in 1906 as "light-house design, mosaic" and listed at $25. *Right:* the bamboo-form base of this lamp with suspended Favrile glass prisms was modeled by Alvin James Tuck. It was listed in 1906, "1 light, bamboo, tall," and priced at $7.

• • • • • •

Summer Bank Holiday (UK)

Monday 29

Tuesday 30

Wednesday 31

Thursday 1

Friday 2

Saturday 3

Father's Day (Australia, NZ)

Sunday 4

AUGUST

S	M	T	W	T	F	S
	1	2	3	4	5	6
7	8	9	10	11	12	13
14	15	16	17	18	19	20
21	22	23	24	25	26	27
28	29	30	31			

SEPTEMBER

S	M	T	W	T	F	S
				1	2	3
4	5	6	7	8	9	10
11	12	13	14	15	16	17
18	19	20	21	22	23	24
25	26	27	28	29	30	

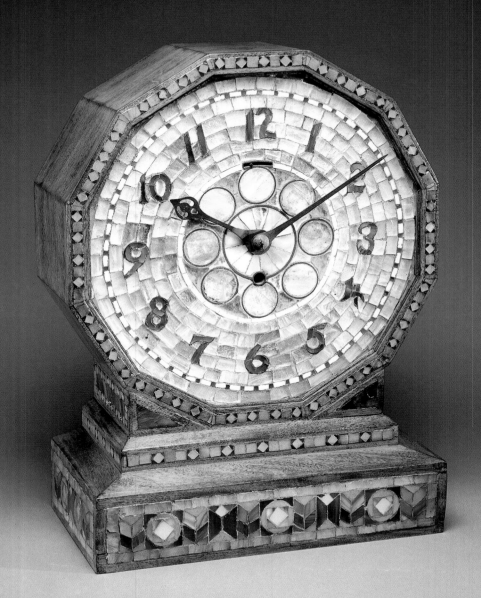

Wood and Favrile glass mosaic clock, circa 1900. This clock's movement was made by the Boston Clock Co.

• • • • • •

September

Labor Day (USA, Canada)

Monday 5

Tuesday 6

Wednesday 7

Thursday 8

Friday 9

Saturday 10

SEPTEMBER						
S	M	T	W	T	F	S
				1	2	3
4	5	6	7	8	9	10
11	12	13	14	15	16	17
18	19	20	21	22	23	24
25	26	27	28	29	30	

Sunday 11

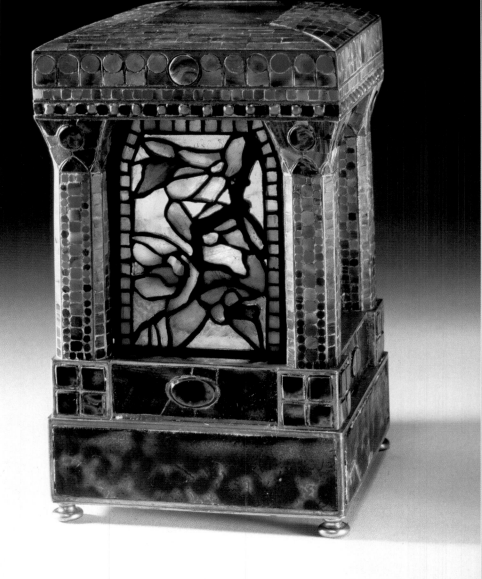

September

Monday	12

Tuesday	13

Wednesday	14

Thursday	15

Friday	16

Saturday	17

Sunday	18

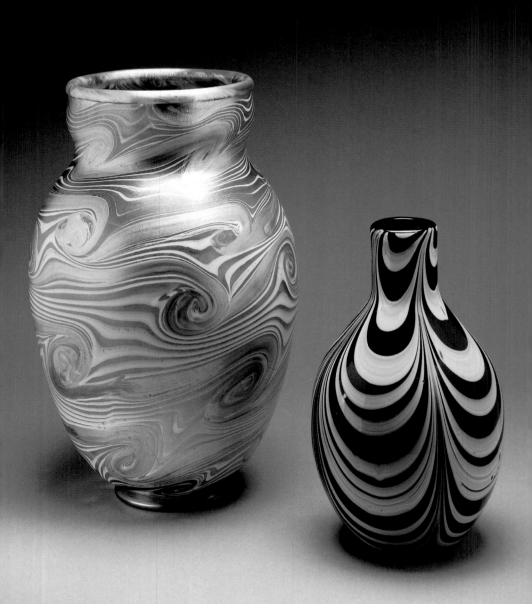

The vase with swirls on the left appears to be marked "A1178," dating it to 1894. The strongly colored vase on the right has a symmetrical swag pattern. It is marked "1476B," dating it to 1907.

• • • • • •

September

Monday 19

Tuesday 20

Wednesday 21

Thursday 22

Friday 23

Saturday 24

Sunday 25

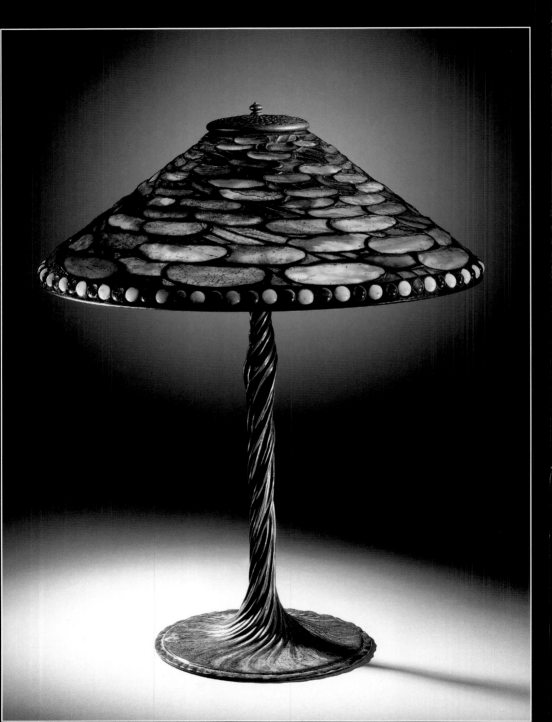

"Lily Pad" leaded-
glass shade, 20 inches
in diameter, on a
base illustrated in
Tiffany & Co.'s circa
1912 Tiffany lamp
catalogue and listed,
"No. 443. Library
Lamp, 26 in. high,
design of Lily stems,
$65."

• • • • • •

Monday 26

Tuesday 27

Wednesday 28

Thursday 29

Friday 30

Saturday 1

Sunday 2

SEPTEMBER

S	M	T	W	T	F	S
				1	2	3
4	5	6	7	8	9	10
11	12	13	14	15	16	17
18	19	20	21	22	23	24
25	26	27	28	29	30	

OCTOBER

S	M	T	W	T	F	S
						1
2	3	4	5	6	7	8
9	10	11	12	13	14	15
16	17	18	19	20	21	22
23	24	25	26	27	28	29
30	31					

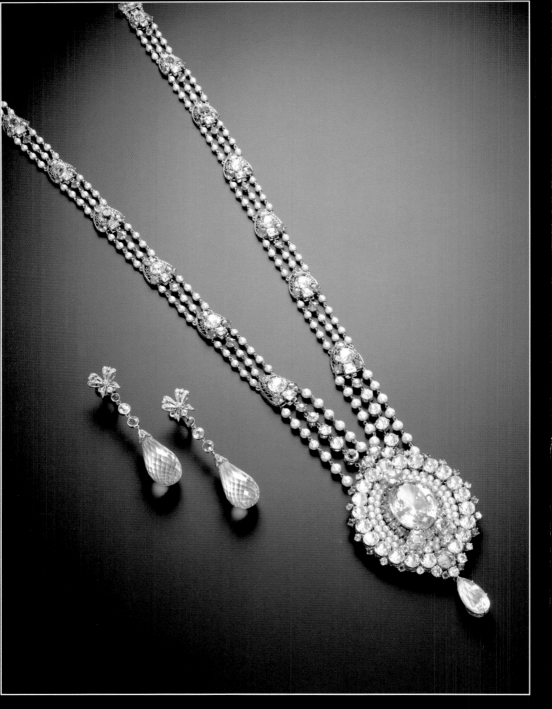

The large oval pendant is set with an oval pink topaz surrounded by pearls, amethysts, smaller pink topazes, chrysoberyls, and diamonds; the triple chain has pearls interspersed with gemstone elements. Both the pendant and the matching earrings have pink topaz briolette drops.

• • • • • •

October

Queen's Birthday (Australia—WA)
Labour Day (Australia—ACT, NSW, SA)

Monday 3

Rosh Hashanah begins

Tuesday 4

Rosh Hashanah ends

Wednesday 5

Thursday 6

Friday 7

Saturday 8

OCTOBER						
S	M	T	W	T	F	S
						1
2	3	4	5	6	7	8
9	10	11	12	13	14	15
16	17	18	19	20	21	22
23	24	25	26	27	28	29
30	31					

Sunday 9

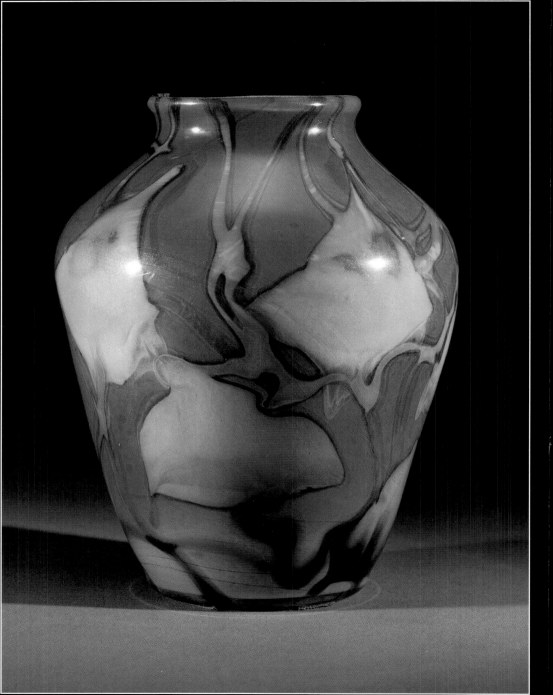

"Reactive glass" vase with a brilliantly colored abstract pattern. The Corona factory made reactive glass with sensitive glass that changed color when refired; in some cases, fumes caused by firing pieces of different colors at the same time created new colors. Marked "Y3788," this vase was made in 1905.

• • • • • •

Columbus Day (USA)
Thanksgiving (Canada)

Monday **10**

Tuesday **11**

Wednesday **12**

Yom Kippur

Thursday **13**

Friday **14**

Saturday **15**

Sunday **16**

OCTOBER

S	M	T	W	T	F	S
						1
2	3	4	5	6	7	8
9	10	11	12	13	14	15
16	17	18	19	20	21	22
23	24	25	26	27	28	29
30	31					

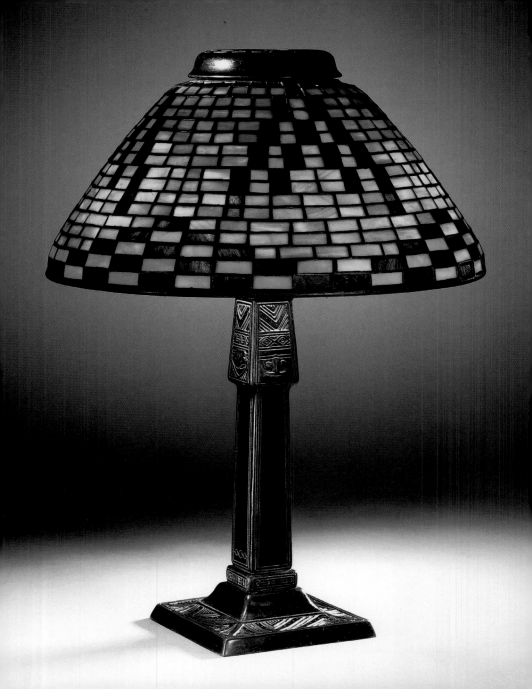

"American Indian" lamp with a leaded-glass shade. Tiffany & Co.'s circa 1912 Tiffany lamps catalogue has a photograph of an identical lamp on page 10; its description reads, "No. 536. American Indian Lamp, 17 in. high, $25. No. 1586 American Indian Shade, 12 in. diameter, $40. Price complete, $65." These lamps were made to accompany the "American Indian" desk set. This lamp sold at Christie's on December 8, 2000 for $88,125.

• • • • • •

October

| Monday | 17 |

| Tuesday | 18 |

| Wednesday | 19 |

| Thursday | 20 |

| Friday | 21 |

| Saturday | 22 |

| Sunday | 23 |

OCTOBER

S	M	T	W	T	F	S
						1
2	3	4	5	6	7	8
9	10	11	12	13	14	15
16	17	18	19	20	21	22
23	24	25	26	27	28	29
30	31					

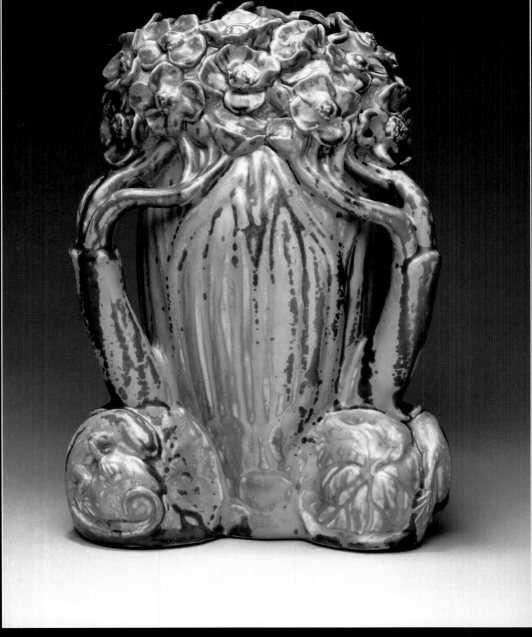

October

United Nations Day
Labour Day (NZ)

Monday 24

Tuesday 25

Wednesday 26

Thursday 27

Friday 28

Saturday 29

Sunday 30

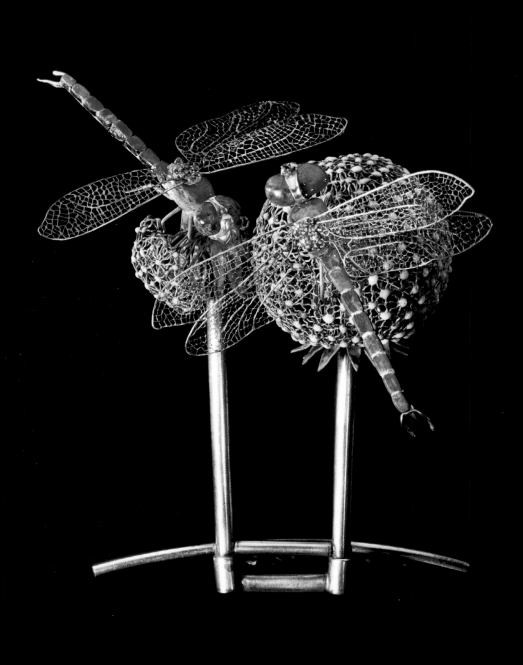

Hair ornament made for Mrs. H.O. Havemeyer, Louis Comfort Tiffany's foremost patron, America's greatest collector of Impressionist paintings, and in her widowhood she became a militant feminist. This piece combined elements from the dandelion seedball and the dragonfly hair ornament that Tiffany & Co. had shown at the 1904 St. Louis Exposition. Here one of the seedballs has been partly crushed by a dragonfly, and the heads and thoraxes of the dragonflies are rendered in pink rather than black opals.

· · · · · ·

Oct/Nov

Halloween
Monday 31

Tuesday 1

Wednesday 2

Thursday 3

Friday 4

Saturday 5

Sunday 6

OCTOBER						
S	M	T	W	T	F	S
						1
2	3	4	5	6	7	8
9	10	11	12	13	14	15
16	17	18	19	20	21	22
23	24	25	26	27	28	29
30	31					

NOVEMBER						
S	M	T	W	T	F	S
		1	2	3	4	5
6	7	8	9	10	11	12
13	14	15	16	17	18	19
20	21	22	23	24	25	26
27	28	29	30			

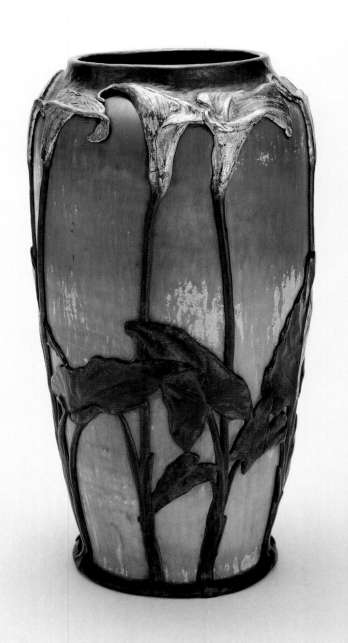

Copper-mounted Favrile pottery vase, 16 inches tall, with silver-plated calla lilies. The markings give no indication of its date, but it may coincide with Louis Comfort Tiffany's venture into "Favrile bronze pottery" in 1908.

• • • • • •

November

Monday 7

Election Day (USA)

Tuesday 8

Wednesday 9

Thursday 10

Veterans' Day (USA)
Remembrance Day (Canada, UK)

Friday 11

Saturday 12

Sunday 13

NOVEMBER						
S	M	T	W	T	F	S
		1	2	3	4	5
6	7	8	9	10	11	12
13	14	15	16	17	18	19
20	21	22	23	24	25	26
27	28	29	30			

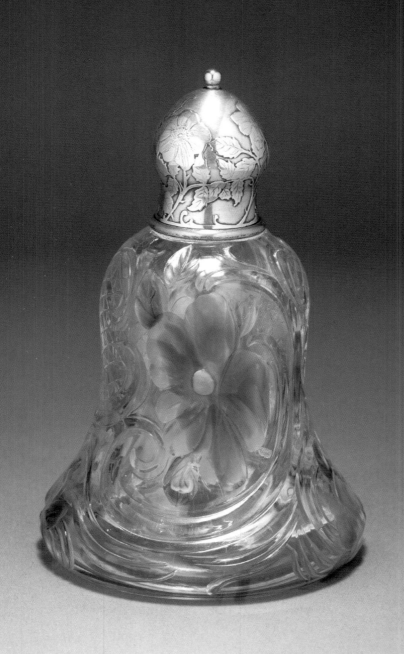

Intaglio-carved glass
fragrance bottle with
a Tiffany & Co.
silver top, both
decorated with wild
roses. The top's
hallmark includes a
"T," indicating that
it was made before
December 29, 1902,
when the mark was
changed to a "C" (for
Charles T. Cook, the
company's new presi-
dent). The glass was
probably carved by
Ernest Flogel.

• • • • • •

November

| Monday | 14 |

| Tuesday | 15 |

| Wednesday | 16 |

| Thursday | 17 |

| Friday | 18 |

| Saturday | 19 |

| Sunday | 20 |

NOVEMBER

S	M	T	W	T	F	S
		1	2	3	4	5
6	7	8	9	10	11	12
13	14	15	16	17	18	19
20	21	22	23	24	25	26
27	28	29	30			

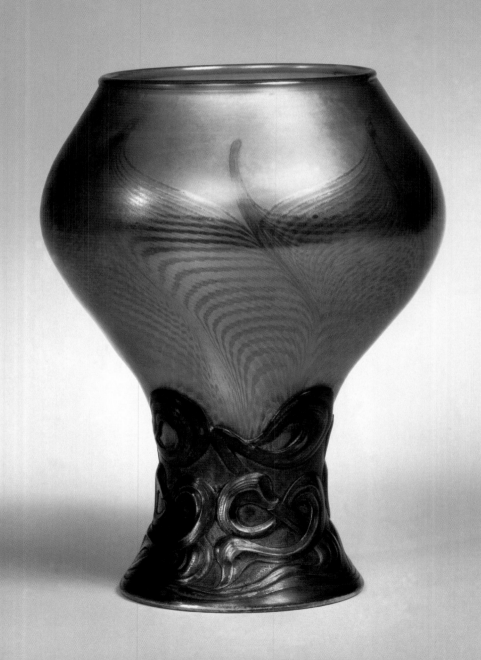

Favrile glass vase with a silver base designed by Edward Colonna, circa 1900. Writing about Siegfried Bing's display of Favrile glass with Colonna's mounts at the Grafton Galleries in 1899, *The Studio's* critic Horace Townsend commented that they "somehow suggest but in now way [copy] Japanese *shibuchi*. Tin, brass, silver, and gold are run in a sort of pattern which is no pattern, into the bronze groundwork with an alluring effect." *Museum of Decorative Art, Copenhagen*

• • • • • •

November

Monday	21
Tuesday	22
Wednesday	23
Thanksgiving (USA) *Thursday*	24
Friday	25
Saturday	26
Sunday	27

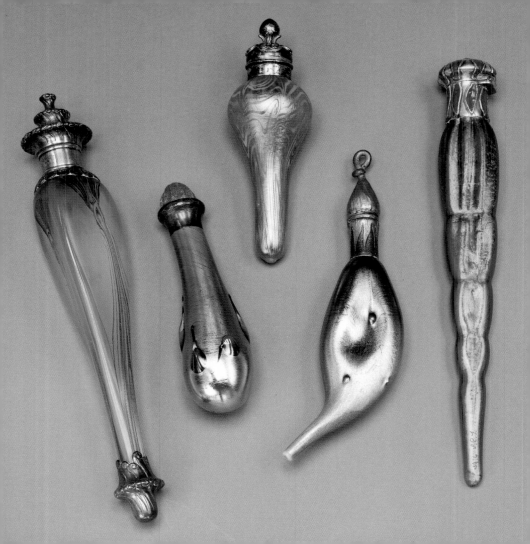

Favrile glass
vinaigrettes with
Tiffany & Co.
silver and gold
mounts, circa
1901–14.

• • • • • •

| *Monday* | 28 |

| *Tuesday* | 29 |

St. Andrew's Day (UK)
| *Wednesday* | 30 |

| *Thursday* | 1 |

| *Friday* | 2 |

| *Saturday* | 3 |

| *Sunday* | 4 |

NOVEMBER

S	M	T	W	T	F	S
		1	2	3	4	5
6	7	8	9	10	11	12
13	14	15	16	17	18	19
20	21	22	23	24	25	26
27	28	29	30			

DECEMBER

S	M	T	W	T	F	S
				1	2	3
4	5	6	7	8	9	10
11	12	13	14	15	16	17
18	19	20	21	22	23	24
25	26	27	28	29	30	31

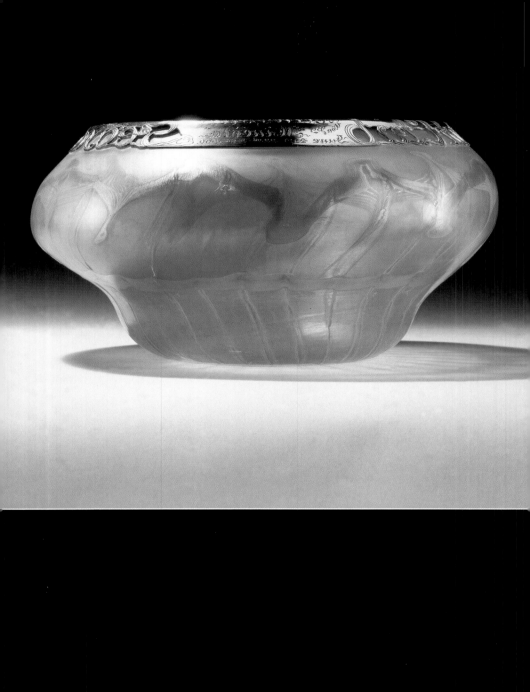

• • • • • •

December

Monday 5

Tuesday 6

Wednesday 7

Thursday 8

Friday 9

Human Rights Day
Saturday 10

Sunday 11

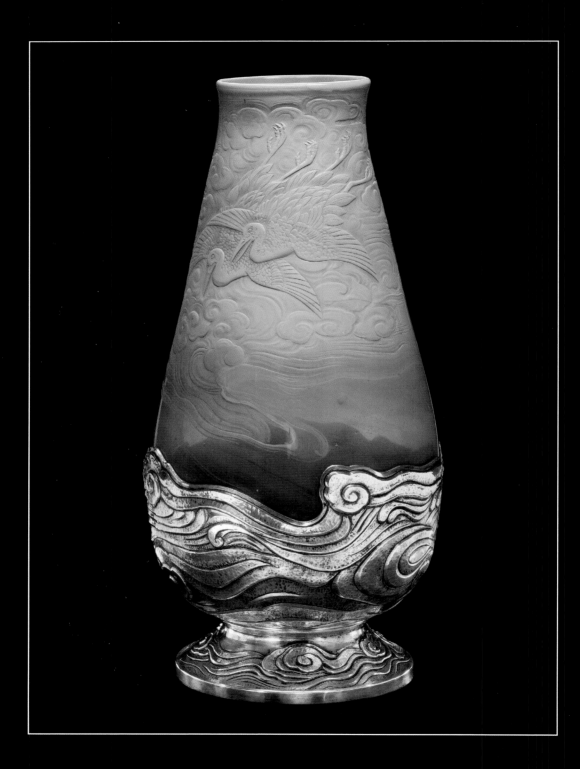

Glass vase carved with flying storks and clouds signed "FK." The initials FK stand for Fredolin Kretschmann, an Austrian-born glass engraver who had worked in the cameo-glass department of Thomas Webb & Sons in England, before emigrating to the United States. He worked at Louis Comfort Tiffany's Corona glass factory until his untimely death in 1898. The silver base was evidently designed by John T. Curran of Tiffany & Co. Kretschmann's swirling mists beneath the clouds are echoed in the base's sinuous, proto-Art Nouveau lines, which are characteristic of Curran's work. The flying storks and clouds echo the work of Tiffany & Co.'s great nineteenth-century silver designer and Curran's mentor, Edward C. Moore, who died in 1891.

• • • • • •

December

D E C E M B E R							
S	M	T	W	T	F	S	
					1	2	3
4	5	6	7	8	9	10	
11	12	13	14	15	16	17	
18	19	20	21	22	23	24	
25	26	27	28	29	30	31	

Monday — 12

Tuesday — 13

Wednesday — 14

Thursday — 15

Friday — 16

Saturday — 17

Sunday — 18

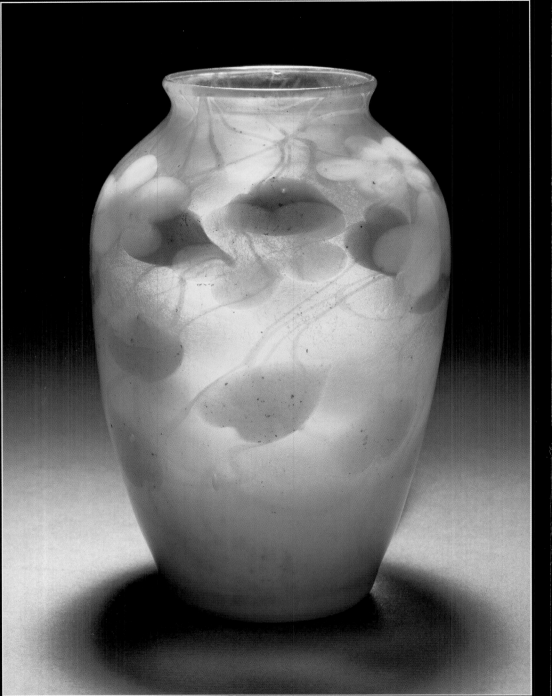

Six-and-a-half-
inch-tall vase with
swirling leaves and
stems marked
"9125A," made in
1906.

• • • • • •

Monday 19

Tuesday 20

Wednesday 21

Thursday 22

Friday 23

Christmas Eve
Saturday 24

Christmas Day
Sunday 25

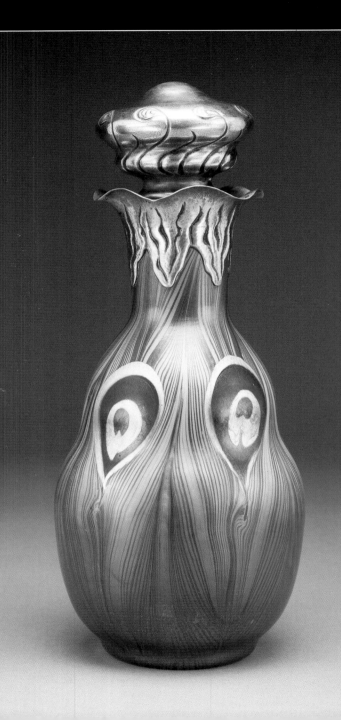

"Peacock" glass decanter with a silver stopper and lip made by Tiffany & Co. in 1902.

• • • • • •

Dec/Jan

First Day of Hanukkah
Kwanzaa begins (USA)
Boxing Day (Canada, NZ, UK, Australia—except SA)
Proclamation Day (Australia—SA)

Monday 26

Tuesday 27

Wednesday 28

Thursday 29

Friday 30

Saturday 31

New Year's Day
Kwanzaa ends (USA)

Sunday 1

DECEMBER

S	M	T	W	T	F	S	
					1	2	3
4	5	6	7	8	9	10	
11	12	13	14	15	16	17	
18	19	20	21	22	23	24	
25	26	27	28	29	30	31	

JANUARY 2006

S	M	T	W	T	F	S
1	2	3	4	5	6	7
8	9	10	11	12	13	14
15	16	17	18	19	20	21
22	23	24	25	26	27	28
29	30	31				

2006

JANUARY

FEBRUARY

MARCH

APRIL

MAY

JUNE

2006

JULY

AUGUST

SEPTEMBER

OCTOBER

NOVEMBER

DECEMBER

2004

January
S	M	T	W	T	F	S
				1	2	3
4	5	6	⑦	8	9	10
11	12	13	14	15	16	17
18	19	20	21	22	23	24
25	26	27	28	29	30	31

February
S	M	T	W	T	F	S
1	2	3	4	5	6	⑦
8	9	10	11	12	13	14
15	16	17	18	19	20	21
22	23	24	25	26	27	28
29						

March
S	M	T	W	T	F	S
	1	2	3	4	5	6
7	8	9	10	11	12	13
14	15	16	17	18	19	20
21	22	23	24	25	26	27
28	29	30	31			

April
S	M	T	W	T	F	S
				1	2	3
4	5	6	7	8	9	10
11	12	13	14	15	16	17
18	19	20	21	22	23	24
25	26	27	28	29	30	

May
S	M	T	W	T	F	S
						1
2	3	4	5	6	7	8
9	10	11	12	13	14	15
16	17	18	19	20	21	22
23	24	25	26	27	28	29
30	31					

June
S	M	T	W	T	F	S
		1	2	3	4	5
6	7	8	9	10	11	12
13	14	15	16	17	18	19
20	21	22	23	24	25	26
27	28	29	30			

July
S	M	T	W	T	F	S
				1	2	3
4	5	6	7	8	9	10
11	12	13	14	15	16	17
18	19	20	21	22	23	24
25	26	27	28	29	30	31

August
S	M	T	W	T	F	S
1	2	3	4	5	6	7
8	9	10	11	12	13	14
15	16	17	18	19	20	21
22	23	24	25	26	27	28
29	30	31				

September
S	M	T	W	T	F	S
			1	2	3	4
5	6	7	8	9	10	11
12	13	14	15	16	17	18
19	20	21	22	23	24	25
26	27	28	29	30		

October
S	M	T	W	T	F	S
					1	2
3	4	5	6	7	8	9
10	11	12	13	14	15	16
17	18	19	20	21	22	23
24	25	26	27	28	29	30
31						

November
S	M	T	W	T	F	S
	1	2	3	4	5	6
7	8	9	10	11	12	13
14	15	16	17	18	19	20
21	22	23	24	25	26	27
28	29	30				

December
S	M	T	W	T	F	S
			1	2	3	4
5	6	7	8	9	10	11
12	13	14	15	16	17	18
19	20	21	22	23	24	25
26	27	28	29	30	31	

2006

January
S	M	T	W	T	F	S
1	2	3	4	5	6	⑦
8	9	10	11	12	13	14
15	16	17	18	19	20	21
22	23	24	25	26	27	28
29	30	31				

February
S	M	T	W	T	F	S
			1	2	3	4
5	6	⑦	8	9	10	11
12	13	14	15	16	17	18
19	20	21	22	23	24	25
26	27	28				

March
S	M	T	W	T	F	S
			1	2	3	4
5	6	7	8	9	10	11
12	13	14	15	16	17	18
19	20	21	22	23	24	25
26	27	28	29	30	31	

April
S	M	T	W	T	F	S
						1
2	3	4	5	6	7	8
9	10	11	12	13	14	15
16	17	18	19	20	21	22
23	24	25	26	27	28	29
30						

May
S	M	T	W	T	F	S
	1	2	3	4	5	6
7	8	9	10	11	12	13
14	15	16	17	18	19	20
21	22	23	24	25	26	27
28	29	30	31			

June
S	M	T	W	T	F	S
				1	2	3
4	5	6	7	8	9	10
11	12	13	14	15	16	17
18	19	20	21	22	23	24
25	26	27	28	29	30	

July
S	M	T	W	T	F	S
						1
2	3	4	5	6	7	8
9	10	11	12	13	14	15
16	17	18	19	20	21	22
23	24	25	26	27	28	29
30	31					

August
S	M	T	W	T	F	S
		1	2	3	4	5
6	7	8	9	10	11	12
13	14	15	16	17	18	19
20	21	22	23	24	25	26
27	28	29	30	31		

September
S	M	T	W	T	F	S
					1	2
3	4	5	6	7	8	9
10	11	12	13	14	15	16
17	18	19	20	21	22	23
24	25	26	27	28	29	30

October
S	M	T	W	T	F	S
1	2	3	4	5	6	7
8	9	10	11	12	13	14
15	16	17	18	19	20	21
22	23	24	25	26	27	28
29	30	31				

November
S	M	T	W	T	F	S
			1	2	3	4
5	6	7	8	9	10	11
12	13	14	15	16	17	18
19	20	21	22	23	24	25
26	27	28	29	30		

December
S	M	T	W	T	F	S
					1	2
3	4	5	6	7	8	9
10	11	12	13	14	15	16
17	18	19	20	21	22	23
24	25	26	27	28	29	30
31						